LONELY PLANET'S
BEST EVER
VIDEO
Tips

LEARN TO SHOOT AND SHARE BETTER TRAVEL VIDEO

CONTENTS

INTRODUCTION

VIDEO IS A POWERFUL VEHICLE for capturing our travel experiences. It's an assault on the senses: image, movement and sound conspire to deliver to the viewer a vivid essence of place and time. Where photography can – literally – offer only a snapshot of a single moment, video can build a montage of sights, points of view and real-time action. At its best it immerses the audience, making them feel like they're really there in the moment, hearing the bustle and smelling the aromas for themselves.

There are many factors that contribute to a great travel video, but don't let that put you off. Thanks to a lifetime's exposure to TV and movie culture, adverts and social media video, we all possess an

Whether you're a novice or a veteran videographer, you'll find tips here to spark ideas and inspire creativity

innate understanding of what makes good video. The 52 tips that follow offer an insight into the practical skills you need to make original and entertaining video, from technical know-how and compositional advice to creative suggestions and editing tips.

You can invest in top-of-the-range cameras, lenses and equipment, but you don't have to. Smartphones can shoot great footage, and editing software is more accessible than ever. The YouTube generation has proven that anyone can connect with an audience; you don't need qualifications or years of experience. Whether you're a novice or a veteran videographer, you'll find tips here to spark ideas and inspire creativity for your next trip and beyond.

BEFORE YOU GO

TIPS BY Teton Gravity Research ✴ Russ Malkin ✴ Lucy Clements ✴ Nick Ray

WHAT CAMERA?
Let's start with the basics: what cameras guarantee you good-quality video?

One option is to use a Digital Single-Lens Reflex camera, more commonly known as a DSLR. These can retail for anywhere from US$600 to $5,000, but even those on the cheaper end of this scale can shoot great video. DSLRs can be outfitted with a variety of different lenses, but we recommend a mid-range zoom lens like a 24–105mm zoom, which is the most versatile.

But if you plan to share your videos via social media or online, the truth is that an iPhone 6 Plus with the maximum memory (132GB) can reap fantastic results. Install the iMovie app to allow you to edit the footage there and then; this technology is so sophisticated and intuitive to use that anyone can produce well-crafted shows on their handset, ready to upload directly to any social media platform. Of course, you may prefer to consider the equivalent Android option.

Don't shoot in portrait
Whichever smartphone option you choose, make sure that you always shoot landscape – that is, hold the phone horizontally – to avoid the wrong aspect ratio in your finished product.

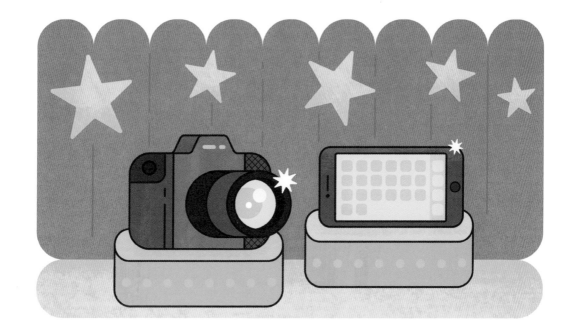

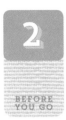

LIFE THROUGH THE LENS

There is a bewildering choice of lenses for DLSR on the market and most videographers need to be selective, for reasons of budget and portability.

The best all-round lenses are the zoom lenses with a good range, such as 24–105mm (1). Both Canon and Nikon offer these models with an image stabiliser, which really helps when shooting video.

If you're set on capturing wildlife, it's wise to invest in a longer lens, but check out the size and weight of the lens in person before ordering online, as some of these lenses will outmuscle the camera itself. Choose a zoom lens with a good range, so you can capture action both far and near. A 100–400mm (2) will do the trick, although it is pricey, so novice shooters might prefer the distinctly cheaper

70–300mm flavour (3). Longer lenses are also favoured by sports photographers, so are good for all-round action shots.

A fish-eye lens or ultra-wide (4) is good for indoor scenes. Favoured by hotels and estate agents hoping to use sleight of eye to lure potential clients, they can make a room appear considerably larger than it is in reality.

Finally, it's hard to beat the sheer image quality of a fixed focal length lens. For decades this has been the 50mm lens (5), as this offers the closest approximation to the image as seen by our eyes.

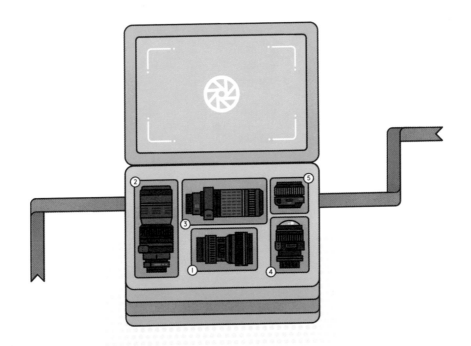

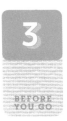

ACCESSORISE

Preparation is everything. Before you leave, think about what you plan to shoot and how location, weather and access to power will affect your production.

》 If you're out for the whole day, bring a couple of extra batteries (1). Anything longer than a day and it's time to start thinking about access to power so you can recharge (2). There are some great choices like Goal Zero for solar and battery packs that can charge on the go. See page 16 for more tips on staying charged.

》 Think about how you will carry your camera and gear. If you're planning to shoot on rough terrain, an adventure camera pack can be a great investment (3). Make sure you choose one with a hip belt, straps for attaching tripods and back support. Check out Dakine and F-Stop packs for some great options.

》 Travelling in a wet environment? Look into drybags and dryboxes like Pelican cases for digital cameras (4). For smartphones there's a huge choice of waterproof cases available: these also serve to protect the phone from dirt and knocks, so it's worth picking a good one like the Lifeproof Nuud or the Otterbox Preserver.

》 If you plan to film any action adventures, consider investing in one or two of the latest technology GoPros (5). These are small and lightweight (so easy to carry with you), versatile and boost videos with a high-octane spin.

》 A list of locations and places or things of interest you'd like to film, along with a written itinerary, can help focus your efforts (6).

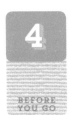

HAVE A PLAN

**Take the time to consider the final product before you
start shooting it – or even before you leave for your trip.**

Are you filming for personal use or to share it with others? Do you want to send the footage back during the trip or store the content while travelling? With a firm understanding of what you're trying to achieve, you can set yourself up perfectly with the right equipment, the right social media links and any other assistance you might need.

Think too about your practical plan of action. For example, do you want to film your travelling companion(s) or film a piece to camera yourself? Do you want to do a voiceover or just a soundtrack? Try presenting to camera before you go to see how you come across and to make sure that whoever is filming gets the composition right and is technically aware of the equipment you're using. It is dreadful to come home to discover that they filmed everything portrait instead of landscape or obscured part of the lens with their finger (this happens more frequently than you think!).

The decisions you make at this early stage will dictate how your final video will look, so engage with your own motivations at an early stage and your efforts will pay off.

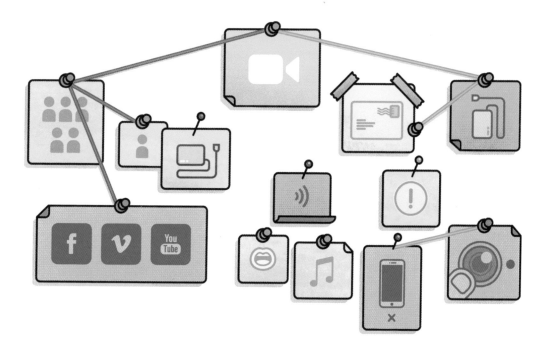

POWER OFF THE BEATEN TRACK

In remote areas, power sources may be unreliable, scarce or simply non-existent. So if you're going off the beaten track, it pays to think ahead.

If you're using a DSLR, pack plenty of spare batteries and memory cards to carry with you on the road. Take any opportunity to recharge, and never just assume that the power will stay on. If you plan to buy a back-up hard drive, it's worth choosing one that can be charged directly from a laptop – that way, as long as your laptop has power, your files can be backed up safely.

If your accommodation doesn't have power, check the local cafés for power sources you can borrow. Failing that, seek out a vendor who charges mobile phones, but be wary of leaving expensive equipment there: it may be too much temptation for someone who earns very little money. Stay with them while recharging, or leave a trusted tour guide with them.

Waste not want not

Be wary of wasting precious battery life on filming for filming's sake. It's frustrating to find that you can't capture that perfect moment simply because you used up so much battery on a mediocre sunset the night before.

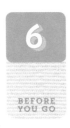

KEEP EQUIPMENT SAFE

Whether it's a top-of-the-range DSLR or just a smartphone, visible camera equipment can make you a target for thieves. Be savvy and stay aware of those around you.

》》 **Check the small print** of your travel insurance to ensure it will cover all your equipment for the entire duration of your trip. There are specialised travel gadget insurers: Travel Gadget Insurance, Protect your Bubble, Gadget Guardian and Gadget Cover.

》》 **Pack expensive equipment in your hand luggage** when travelling by plane or bus, never in the hold.

》》 **Stay in self-contained rooms, not dorms.** Shared rooms may be cheaper, but in dorms you have no control over who can gain access to your stuff.

》》 **Leave expensive items in a safe** or with reputable receptions rather than in your room. Best of all, keep them with you. It can be annoying, but not as frustrating as returning to a room and finding them gone.

》》 **Keep your luggage on your lap** or under your feet on public transport.

》》 **Buy a camera bag** that can't be easily opened without you knowing. Wear it on your front in crowds and pack expensive items deep. When you are shooting, always keep the camera strap around your neck.

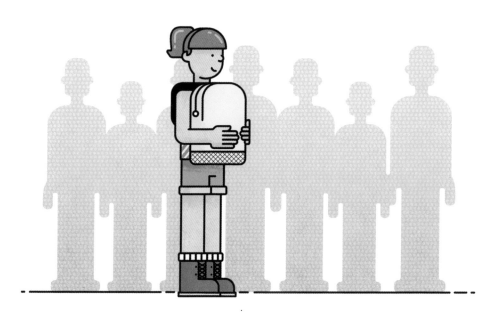

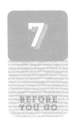

TRIPODS

Tripods are a frontline weapon in the battle for better video. Broadly speaking, the bigger (or heavier) the camera, the more stable the tripod needs to be.

Tripods are best used for dramatic landscapes or buildings where the action is incidental to the scene. People, animals or vehicles might come in and out of shot, but it's the iconic Himalayan peaks or the towers of Angkor Wat that you're after. Combine this with a sunrise or sunset and the opportunity for a time-lapse presents itself, an advanced trick to speed up nature that definitely requires a tripod (see page 52).

Gorillapods are some of the most compact and reliable tripod devices on the market, for use with a smartphone, tablet or light camera. Retractable monopods are another good option for a more elevated perspective. Bigger tripods can be a burden to carry around, but will help to get the money shot if you've already invested in a quality camera.

As real-world action unfolds unpredictably, you may not always have time to set the tripod. Handheld shooting captures the energy of the moment, particularly when lots of things are happening at once. For a presenter-style format with people talking to camera, handheld offers the classic walk-and-talk approach.

Handheld and hangovers don't go together, as there is a serious chance of visible handshake, but image stabilizers on pro cameras can effectively cancel this out.

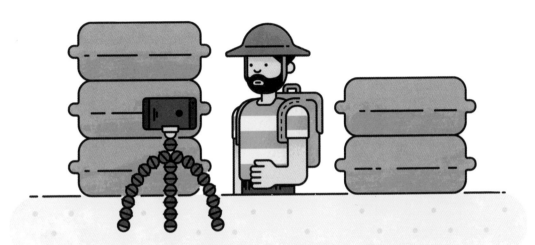

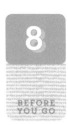

BACK UP

You might have filmed the footage of a lifetime, but if the card corrupts or your camera is stolen, it's useless.

Always keep a copy of the files in at least two places, and not on memory cards which are prone to corruption when being copied over. Online storage providers such as iCloud, Dropbox or Flickr are good options for smartphone footage. But uploading will require a lot of data, and storing large files will become expensive, so this option isn't realistic for most DSLR shooters.

Take a fast card reader, and ideally two robust hard drives that can withstand being knocked around in backpacks on the road. Check the specifications of the camera and choose the resolution at which you want to film. A 16GB card will give you around 44 minutes in HD on most DSLRs. Calculate how much space you need, always erring on the safe side (better to have too much memory than too little).

Keeping a list of what's been filmed on each card will save you a lot of time when you're editing. See page 108 for more tips about storing and organising your digital files.

Plan ahead
If you plan to store a copy on your laptop, make sure you have enough memory available before you leave home.

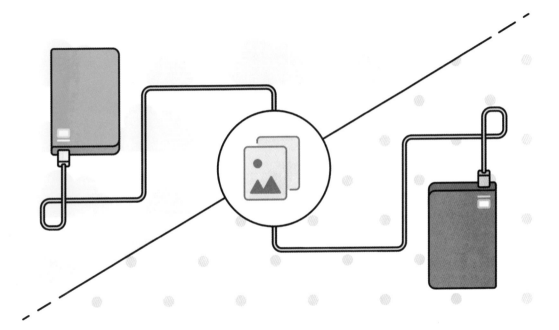

AUDIO

Many amateur videographers spend a lot of time and money on images but ignore the importance of sound. Do so at your peril!

Audio is often more important than the picture. With bad audio your piece to camera will be unusable, but with good audio you can lay good pictures over the top of bad images. Always keep the camera close to the person speaking and ideally do a test run and listen back to it before filming your final version.

If you're shooting with a DSLR or smartphone, ensure that any sound you want to capture is within three feet of the camera. If that won't always be possible, consider buying a top mic: Rode make excellent quality microphones –

try the Rode VideoMic Go, which is compatible with many HD DSLRs, or the Rode Smartlav for iPhone – both at US$100 or less. These mics plug directly into your camera, so they don't require batteries, and the audio will sync up automatically in post-production.

Use airplane mode

If you're using a smartphone, remember to switch to airplane mode before you start recording to avoid the possibility of your recording being interrupted by a phone call!

HAVE A CHECKLIST

Once you have established your equipment and who is presenting, have a checklist to make sure that you shoot everything you need.

1 **A good establishing shot** (see page 40): this tells the viewer your location and gives you the opportunity to add a graphic with the title of the project in post-production.

2 **Your opening piece to camera,** which again should establish what you are doing and perhaps what you are about to do. Don't be scared to show your emotions, even if you're tired, hungry or fractious: it makes good viewing to witness how you react to situations.

3 **Shoot plenty of sequences** of the sights you are seeing or the adventures you are having. Always hold the shot for at least five seconds. If you are doing a left-to-right pan you'll

need a very steady hand or a small tripod (see page 20). You can later use voiceover over these sequences or even lay these pictures over the sound from your pieces to camera.

4 **If appropriate or available, use sound bites** of brief interviews with local people to add colour to your piece. Get tips on interviewing on page 62.

5 **Summarise at the end of the piece** what happened, your thoughts and emotions, with a tease to the next episode or the next online segment/clip if applicable. You should always aim to leave the viewer wanting more.

PRACTICE MAKES PERFECT
The old adage may be an overstatement, but it will certainly help improve the results. Don't let the camera make all decisions for you.

--

Consider using some still shots as a marker to set the frame for the video. Almost every device on the market combines photos and videos these days, so take the chance to snap some photographs first and see which composition works best. This is especially useful for those shooting on a tablet, as the huge screen is the amateur answer to a director's monitor.

If time allows, go for more than one take using different settings, and take a closer look at the results. It might be a different app feature on a smartphone or a different white balance on a DLSR, but small changes can add up to big differences in results. It's easy to shoot

on automatic and let the camera make the decisions, but to improve your skillset as a videographer, you need to start making these calls yourself, particularly if you've invested in expensive equipment.

There's no need to limit yourself to shooting on a traditional DSLR camera. There will be times when you don't have one with you when an interesting scene unfolds; it'll still be worth capturing on a smartphone or tablet. While the quality of the end product may not be quite as good as that obtained with an expensive DLSR, the methodology is exactly the same.

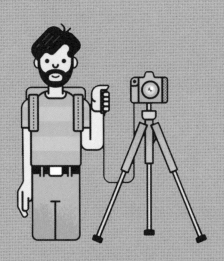

CHAPTER

2

TECHNICAL TIPS

TIPS BY Russ Malkin ✳ Lucy Clements ✳ Nick Ray ✳ Nadine Sykora ✳ Teton Gravity Research

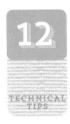

THE RULE OF THIRDS

Whether you're shooting stills or video, good composition is critical: without it, even the most compelling of scenes can look unbalanced or boring.

The rule of thirds can help you get your composition right. When you look through your viewfinder or at your screen, imagine three evenly spaced lines running horizontally and another three vertically, giving you a total of nine rectangles. Following the rule of thirds, the subject of the shot should be placed on or near where the lines intersect.

Non-moving subjects lend themselves especially well to the rule of thirds. In a landscape, find the main point of interest – a hut on a mountain, perhaps, or an elephant in the savannah. If you're interviewing a person, the main point of focus should be their eyes.

Be careful: autofocus on DSLRs and smartphones is usually in the middle of the frame. Use the focus-lock function on DSLRs by centring on your subject, half-depressing the shutter release until it locks focus, then recomposing your shot. With smartphones it's even easier: just touch and hold the screen on the subject, and it will find and lock focus accordingly.

Don't be a slave to the rule of thirds, though. As long as you understand it well, you should feel free to experiment and discover what unusual compositions can do for your video.

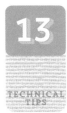

TECHNICAL TIPS

THE HOLY TRINITY OF EXPOSURE
Modern digital cameras are fully automated and can make the decisions for you. Improve your game by learning how to fine-tune your settings manually.

Aperture refers to the hole in the lens that lets light into the camera and is measured in f-stops. Somewhat confusingly, a smaller f-stop value refers to a bigger aperture and a larger f-stop number refers to a smaller aperture. Your choice of aperture size will dictate the depth of field – see page 36 for more details.

Shutter speed refers to the length of time the shutter is open while the image is captured. This relates more to photography, as the shutter stays open throughout a video shoot anyway. However, for those also shooting still images, a slow shutter speed (with tripod) can be used to capture artistic images of a waterfall by day or traffic by night.

ISO dictates the light sensitivity of the camera. In general, the brighter the light, the lower the ISO setting: 100 is a good benchmark for daylight conditions.

Shooting at night
The darker the location, the higher the ISO will need to be; with today's technology it is possible to shoot a night scene without lighting, by ramping up the ISO to 3200 or more, although the image may be blurred or pixelated once expanded.

TECHNICAL
TIPS

DEPTH OF FIELD

Depth of field relates to how much of your shot is in focus. A small amount of focus is called a *shallow depth of field*, the opposite is a *deep focus*.

--

For a polished, cinematic effect, use a shallow depth of field (giving focus to a single item, with everything else in the shot appearing blurry). To achieve this on a DSLR, use a large aperture setting (that is, a small f-stop – see page 34) to target a precise point of focus. Be careful to double check that your object is sharp – it's easy to accidentally find focus on, say, the eyelashes rather than the eyeballs, and tricky to tell on a small screen.

If you are struggling to achieve as shallow a depth of field as you'd like, try moving further away and zooming in on your subject; this will mark them out from the background.

If you're shooting on a smartphone, tap and hold the screen to lock the focus where you want it. The AE/AF lock sign will appear.

If you'd rather shoot with deep focus – perhaps you'd like to present a bustling scene for the viewer to absorb in its entirety, instead of just drawing their attention to a single point – use a small aperture (a larger f-stop).

Take time to play with different focus effects, with blurry foregrounds, blurry backgrounds and focus pulls – a technique where you change the point of focus during the shot.

DON'T CROSS THE LINE

**The 180° rule is one of the central tenets of film making.
Stick to it, unless you have good reason not to.**

Imagine a woman and a man in conversation. The woman is sat on the left-hand side of the screen, facing the man on the right-hand side. Imagine a straight line going through both of their heads and continuing either side forever.

The 180° rule states that this imaginary line should not be crossed in any of your shots. If it is, the on-screen positions of the woman and man will be switched, so that the man is on the left-hand side, looking right. For the viewer, who now isn't sure which subject is where in relation to the other, this is both confusing and distracting.

This same rule applies to objects, and particularly to how people relate to them in a scene. If a woman is walking towards a tree and you cross the line, she'll flip positions on screen so it looks to a viewer like she's walking the other way.

If you do have to cross the line for any reason, try to take a shot where you're on the line filming the person or subject directly so that you can use it as a transitional shot.

As with all rules, this one can be broken – crossing the line creates unease and tension for the viewer, which might be the effect you're going for – but you should make sure that you're doing it on purpose.

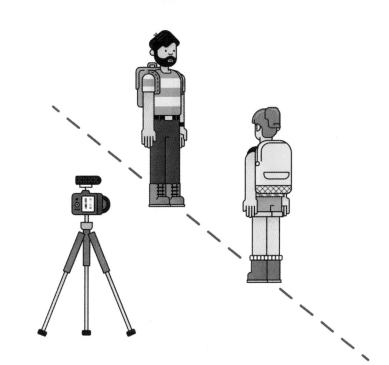

16

TECHNICAL
TIPS

KNOW YOUR SHOTS

Varying the shots in your movie will serve to hold the viewer's attention and by using certain shots you can direct the viewer's emotions.

- -

A **wide shot** sets the scene for the audience, letting them know where they are.

The closer a person or a subject to the camera, the more the audience understands their significance. A **long shot** shows the whole person, a **mid shot** shows the waist up, a **close-up** shows head and shoulders. Closer than that – just eyes or mouth, say – is more intimate than we would normally see a stranger, so the audience will feel a deeper connection to them.

A **point of view shot** can give insight into the subject's thoughts. If we see someone looking

intently at something, then see a door from their point of view, we understand they're awaiting an arrival.

Tracking the camera forwards or backwards, **tilting** it up or down and **panning** it left or right all create movement in the shot. See page 42 for more on tracking and panning.

If you want to add a feeling of drama, move away from the eyeline, so that the camera is looking up or down at something. A **top shot** looking down on the action gives the viewer a feeling of power, while a **low angle** gives the impression that the subject is dominant.

WIDE

LONG

MID

CLOSE

POV

TRACKING

TOP SHOT

LOW ANGLE

TRACKING AND PANNING

Tracking is usually the preserve of handheld shooting and panning is best done with a tripod. These techniques can create movement and bring a static scene to life.

Tracking is a film industry term for shots taken on tracks using a camera mounted on a dolly, but this isn't really a backpack-friendly option for travellers on the road. But the principles of tracking can be applied from any vehicle in any region of the world. Track wildlife from a 4x4 on an African game drive. Track river scenes from the bow of a slow boat down the Mekong River. Anything that moves can be used as a vehicle to experiment with tracking.

It's even possible to track on foot, but you'll need a steady hand and even ground. Handheld tracking is definitely not for scenes in snow and ice or sand or rocks, so forget any mountain or desert experimentation.

One of the most rewarding uses of **panning** is the reveal, coming off a close-up subject to reveal a wider, dramatic scene. Start on a Buddhist carving before panning round to reveal the temples of Bagan scattered across the Irrawaddy plain. Focus on a flower before panning round to reveal a landscaped garden.

Panning is also good for crowd shots. Pan across a room at a dinner party and familiar faces appear and disappear in and out of shot, achieving a completely different effect to filming the same scene from a wide position.

18

TECHNICAL
TIPS

YOU'VE BEEN FRAMED

It's not just what's in the frame, but what's out of the frame. It might be a random tourist about to interrupt your Oscar-winning moment. Or it might be a saffron-clad monk that will add a blaze of colour.

When shooting iconic buildings in video, it pays to have some motion in the shot. A photograph can capture the Angkor Wat or the Taj Mahal in all its glory, but when shooting video, life and energy will give the footage real flourish. Keep one eye open on the environment around you before you shoot. Tourists don't generally enhance the scene, but a local family in traditional costume will bring the building or back-ground scene to life.

When shooting with roads in the foreground, look out for iconic vehicles coming into shot. The Royal Palace in Bangkok looks dazzling by day or night, but nothing brings it to life like a Thai tuk-tuk zipping past. Likewise in a local market, the colourful fruit and vegetables will bring the image to life, but having some local hawkers walk through the shot puts a human face to the scene.

Hold the shot

Once someone or something enters the frame, make sure you keep filming until they exit the frame stage left, as this will help with the editing later.

TECHNICAL TIPS

AVOID THE ZOOM

Using the zoom option is an easy trap to fall into for first-time videographers making the step up from photography.

The zoom button is a great feature when taking still images, as it lets the user get closer to the subject without the need to move. However, migrate the same zoom feature to a video and the audience is likely to end up with motion sickness. Move closer instead.

From a technical point of view, the more you zoom in on a subject, the less stable the image and it is likely to result in a wobbly or blurred video. Resist the temptation to zoom and instead move closer to the subject if practical. Of course, there are exceptions such as sporting events or restricted areas of a museum where it may not be possible

to get closer to the action, but there is still no need to zoom while filming.

Simply shoot the wide shot, stop filming to zoom in and then shoot the close up. It will save a rollercoaster ride for your audience and deliver a more professional result.

If you plan to move closer while shooting to make sure you don't miss the action, then consider the excellent range of GoPro accessories. The GoPro is one of the most compact cameras out there and accessories include the 'Chesty' or chest harness, which is the cheapest 'steadicam' on the market.

LANDSCAPES

The secret to stunning landscape shots can be summed up in one word: light. This means you have to be on location at the right time.

The ability of light to transform a subject or scene from the ordinary to the extraordinary is one of the most powerful tools for photographers and videographers. The good news is that warm daylight is available to everyone, free of charge. The bad news is you might need to set your alarm clock to catch it...

The best light is created by the low angle of the sun in the one or two hours after sunrise and before sunset. At these times shadows are long and textures and shapes are accentuated. Shooting in this light you'll find you can capture a sense of the full magnitude of the scene in front of you. In the right light, landscape shots can look warm, dreamy and ethereal.

Success in capturing these moments hinges on scouting the area you want to shoot before filming it. When you do, ask yourself practical questions. What do I need to capture this moment? Where will I set up my camera? Do I need a tripod? Take time to focus on what is most video-worthy about the landscape – whether it's the sky, mountain or other natural features. With such a limited window of time to film in perfect light conditions, good planning is key.

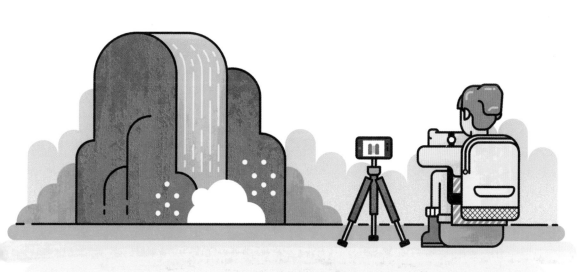

WILDLIFE

Shooting wildlife is like fishing; you need to have the patience of a saint. Just make sure you have the camera ready to go at a moment's notice.

--

Getting the perfect footage is often a matter of luck: being in the perfect place at the right time. It is easy to get frustrated, but remember you cannot control the wildlife; you have to let it come to you.

Keep a camera close at hand and ready to shoot at a moment's notice. If you have to fumble with a bag or lens cap, chances are you will miss the moment. If shooting with a DSLR, use the lens with the longest possible zoom, because it's unusual to get very close to wildlife. When you spot animals in the distance, the eye will zoom in on them and exaggerate their size, but they will be significant on the sensor when you watch your footage back.

Even if you're travelling independently, joining a tour to see the local wildlife is an option worth considering, and often it's the only way to catch a glimpse of your target species. You'll benefit from having a knowledgeable guide or naturalist who will point out the animals and direct the vehicle or boat to areas of recent sightings. Always remember to respect the animals you are filming: you are in their environment.

TIME-LAPSE SEQUENCES

Shooting video in time-lapse is the process of capturing lots of photos over a period of time and assembling them to create a sequence that appears sped up.

- -

TECHNICAL TIPS

If you choose a place with as much movement as possible – a festival or traffic junction – your time-lapse will appear as an onslaught of activity, conveying a sense of hectic energy. Choose a very slow-moving subject – the sun setting or a seedling growing, for example – and a time-lapse will transform it into one smooth motion.

If you're shooting with a DSLR, set the focus manually, so that the image won't auto-focus mid-lapse. Consider your exposure: if you're doing night-time lapses, you'll need a low f-stop to let in a lot of light. Interval times depend on your subject; try out the suggested settings below, but you'll need to experiment to find out what works best for you.

Recommended intervals:

- ❋ 1 second intervals: traffic, crowds
- ❋ 3 second intervals: clouds, sunsets
- ❋ 15–30 second intervals: celestial motion, sun moving across the sky
- ❋ 2+ minutes: construction projects, plants growing

If you have an iPhone with iOS 8 or higher, you can shoot time-lapse video in the device's native camera app. It generally shoots at around 0.5 second intervals, though interval time depends on the length of your recording.

Always use a tripod: time-lapse will make even a hint of camera shake much worse.

TECHNICAL TIPS

ACTION

Whether it's a snowboarder carving up the slopes or a game of football, action sequences can give your video a dynamic edge – if you get them right.

The most important factor is communication. Talk to your subject and understand where they will go. Without doing this the shot will never be as smooth or look as good. Sometimes this can be as simple as yelling back and forth to establish the direction of movement. You could even buy a cheap pair of handheld radios or agree a rough plan on paper.

Aim to include a lot of foreground in your frame to show the depth of action. Start to move the camera before the subject comes into the frame and you'll be rewarded with a much more fluid shot, without that involuntary jerk when the action starts.

Light and timing are also critical. The light in the morning and evening provides some of the best environments to shoot action, and the contrast really helps the subject pop out of the background. The light also helps you see the contour of what you are shooting. When the light is directly above you at midday the features will look flat and it's difficult to distinguish features from a distance; a softer light helps you to see the contour of what you're shooting.

ADVERSE CONDITIONS

It's not all sun, sea and sand when travelling overseas. There will be many times when the elements are against you, and it pays to be prepared.

Travelling in the tropics during the monsoon brings heavy rains, although such downpours are just as likely in Europe or North America at any time of year. Torrential rains and tropical storms are stunning to capture on film, but can be a disaster for your equipment. Travel with a dry bag to keep the camera gear safe. This will also be useful if you are planning any kayaking, rafting or diving.

Extreme heat leads many visitors to want to chill out in air-conditioning. This is not always good for the equipment, as the dramatic changes in temperatures can lead

to condensation or fogging of the lenses. Remember to take the lens to breakfast to give it time to warm up or leave it in a sealed bag inside a cupboard overnight.

Snow conditions are a real challenge for videographers, as the glare plays havoc with the white balance. Use filters if you have them or consider shooting through your goggles for a tinted effect. Batteries need to be fully charged as they drain faster in the cold. And don't change lenses on the slopes: the snowflakes may look pretty, but will soon turn ugly if they land inside the camera.

25

TECHNICAL
TIPS

BRIGHT SUNLIGHT

Lovely as it is, bright sunlight makes it nigh-on impossible to expose your footage correctly. But there are a few tricks you can try in the midday sun.

》 If you're filming a person, seek shade and try to find a shady background too. Or create your own shade using an umbrella.

》 If you have a light, try filming into the sun while lighting the subject from the front. If you don't have a light, find something reflective that can bounce light back on to the subject.

》 Moving further back and zooming in on your subject will let in less light.

》 Check the ISO settings to make sure that they are as low as possible and reduce the aperture (see page 34). Use a lens hood to avoid lens flares. A polariser or ND filter attached to the front of the lens will have the same effect as putting sunglasses on.

》 Some smartphone camera apps allow you to alter exposure. On the iPhone iOS 8, tap on the preview to bring up the focus point; when the sun icon appears, tap and hold to bring up a fine-tuning slider.

》 Finally, if you can't beat 'em, join 'em. When your exposure just won't behave itself, try using the bright sunlight to create interesting and intriguing silhouettes instead.

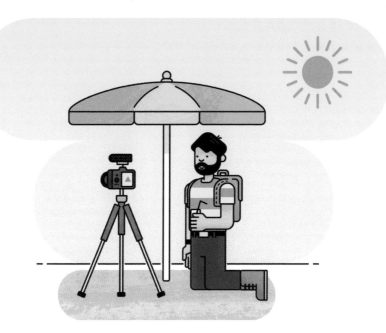

TECHNICAL TIPS

IN THE DARK

If it is truly pitch black, it's important to get some kind of light source from somewhere, and to make sure that your subject is facing the light source.

Use any light source you can find and experiment. Sometimes pointing a light directly at a subject can give a harsh look, and make them squint, so try bouncing the light off a wall at them. Try lamps, torches, candles, anything you can find – then plan your shots around where the light is best.

If you have a light on your smartphone or camera, turn it on. Alter the ISO levels to let in as much light as possible. Beware that increasing the ISO will add grain to your footage, so get to know your camera and figure

out how much grain is acceptable to you before the shot becomes unusable.

Staying zoomed out will let in more light, as will lowering the shutter speed and opening up the aperture.

Be focused

Be aware that a wide open aperture will make focusing trickier as it will give you a shallow depth of field, so double check the focus before you start filming.

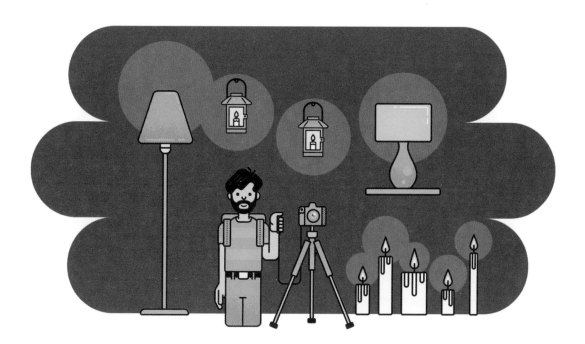

TECHNICAL TIPS

INTERVIEWS

It can be daunting for your subjects to be filmed when they're not used to it, so try to make them as comfortable as possible.

--

》 If possible, position the camera on a tripod and stand just to the side, so that the interviewee can look at your face and see your expressions. If not, tell the person if you want them to look directly into the camera or give them another reference point on which to focus, to stop their eyeline from shifting around.

》 Ask a couple of easy questions to start with, to get them warmed up. Have a list of questions ready, but don't forget to listen to what they say and ask follow-up questions to their answers.

》 Ask open-ended questions and make sure you ask about emotions: how did the person feel when that thing happened?

》 Keep the camera rolling at the end of the interview, but let them think you've switched it off. Chat casually; they will speak more freely when they feel under less pressure.

》 Leave space for editing before asking the next question and, unless you are in the film yourself, try to avoid murmuring noises of agreement when they're talking – it makes editing tricky and may mean you can't use that perfect clip.

WILD AUDIO TRACKS

If your video involves people talking to camera, your future self may well thank you for remembering to film a wild audio track while you're there.

When your video is in post-production, you may find you want to edit out irrelevant parts of a rambling interview or cut to a reaction shot or a cutaway. The problem with editing speech in this way is that the ambient sound behind your speaker might change slightly – just enough that the audience will be able to tell you've made an edit. The issue is more acute when you're in a busy marketplace or bar, but it can still be a problem for relatively quiet locations like nature reserves, because of cicada sounds or bird calls.

To create a wild track, film a 30-second audio recording of the location's ambient sound, without people talking directly at the camera. When you edit, you can lay the audio under the entire scene, so that the ambient sound continues and the flow of the edit remains uninterrupted.

This can also prove useful when you have cutaways or montages that call for ambient sound rather than music. It works especially well with busy traffic spots, marketplaces, rivers and rain scenes.

29

TALKING TO CAMERA

Talking to camera seems simple, but takes time and practice. The most natural way is to 'vlog', aka to hold your camera up with one arm and talk to it.

Start small. The bigger the camera, the more intimidating it will be to start talking to it. Start with a smaller compact camera, like your smartphone or a point-and-shoot.

Check your lighting. Nothing is worse than vlogging with your face half lit with odd shadows, or completely in the dark, so choose your positioning with care.

Learn your camera's field of view. With practice you will learn to imagine what the camera sees and the frame it will be filming. If you have a flip screen, you can use it to check your frame, but make sure you flip it back to avoid the distraction of staring at the screen.

Keep it short, simple, concise and to the point. Holding a camera up gets very tiring very quickly. This isn't an article or blog post, and if you're not used to talking in front of people, it will be very hard to hold the viewer's attention for longer periods of time.

Use the five Ws. If you are stumped on what to say, tell the viewer who you are, where you are, what you are doing, when you are doing it and why.

BE LIKEABLE AND AUTHENTIC

The most successful vloggers are those who can learn to communicate with their audience naturally, allowing their personality to shine through.

» Think about staring right into the camera, as if you are talking to a friend. Talk right through the lens so your eyes can connect to the viewers on the other side.

» Don't worry about talking in complete sentences. Feel free to leave in giggles, pauses, mess-ups, goofy moments; it's what adds that authentic appeal.

» Be honest. Not everything is great; things are weird, gross, odd. Talk about them! Pointing out beautiful sunsets gets boring really quickly.

» Be more lively and excited than usual, because video is best slightly exaggerated.

That's not to say you should be cartoonish, but speak up and talk with assertiveness. You are trying to engage and entertain others.

» Learn the universally flattering camera angle of the 'downward pointed view' and try to get as wide a lens as possible. Use a variety of angles: some full wide shots, some close-ups, some long and some medium-length shots. Viewers like to see you and your surroundings in the same shot, not just a floating head talking to camera.

» It can be harder to express yourself in voiceovers, because you only have audio to help you make your point. Speak as casually as you normally would.

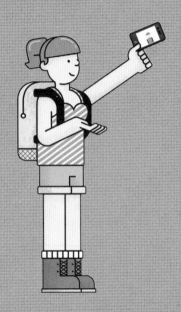

CHAPTER

3

CREATIVE TIPS

TIPS BY Lucy Clements ✳ Nadine Sykora ✳ Nick Ray

CONNECT WITH YOUR AUDIENCE

Every video you make should aim to engage its audience (whether that's your friends or the world at large) and to draw an emotional response.

Any film can dispassionately present a subject, a person and a place, but you'll have something much more emotive if you can find an element of uncertainty or danger to run through it as a subtheme. Watch nature programmes to see how they engage their audience by showing what's at risk: if the lion doesn't find water soon he will die; if the calf remains sick the herd will leave it behind. Find the conflict and delve deeper – show the audience what to care about.

Find the angle that has the power to surprise you, as a filmmaker: that's what will hook your viewer too. Generally, this means seeking the human stories behind what you're shooting. So if you're visiting a historical monument, find out what the building means to the local people. If you're filming a local fisherman, ask him questions about his own experiences. You might be surprised by some of the answers – he doesn't know how to swim, perhaps, or he loves being with the stars every night. These are the details that make an ordinary video into an extraordinary one.

THE POWER OF SUGGESTION

Never assume it's only content that matters. The combination of shots and audio you use fires off synapses in the viewer's mind, reading significance and attaching meaning.

--

Watching a film is not a passive activity: viewers are constantly examining, analysing and trying to fill in any blanks in their mind using their imagination. As such, they will make connections and read deeper meanings that haven't been explicitly made. This can be useful when you're aware of it, but dangerous if the audience reads something you hadn't meant to imply.

The great Alfred Hitchcock said once that if he showed a clip of an old man and followed it with a clip of a mother and baby, the audience would infer that the old man was a nice elderly gentleman. If he showed the same clip of the man followed by young women in bikinis, the audience would likewise make assumptions, this time understanding him to be a lecherous old man.

Show a woman followed by a plate of food and the audience will think she's hungry, no matter how neutral she seems.

It's the film-maker's most powerful tool. Staying conscious of these connections will help you to control them and steer the viewer's emotions to maximum effect.

CREATIVE
TIPS

THE ETIQUETTE OF FILMING

The most rewarding trips are always undertaken with sensitivity towards the country's people, their beliefs and their practices.

» Before you go, research local cultures and taboos, especially with regard to clothing, greetings, time keeping and personal space. Remember that you are the visitor: embrace cultural differences, even if you don't agree with them, and be patient with and respectful of the local customs. As a general rule, if you are warm and open with others, they will be warm and open with you.

» Be careful of filming without permission, especially when at close range, which will almost always raise suspicion. Always ask first and explain the purpose of your film to reassure them. If they refuse to allow you to film, respect their wishes.

» Carry some small change with you: people will often be all too happy to be filmed if you buy them a drink or give them a tip.

» Be careful that your words aren't lost in translation. Sarcasm isn't universal, and humour differs all over the world: you might find yourself being rude without meaning to. Listen to how the locals converse with one another, and try to adapt accordingly.

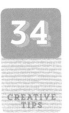

VLOGGING IN PUBLIC SPACES

You will probably need to film yourself in a public space at one time or another – a less than pleasant prospect if you're easily embarrassed.

People will stare at you, yes – but it's no big deal. We live in a selfie culture now: it's very normal to take photos and videos of yourself. For those who look at you askance, don't worry: chances are they will never see you again and will forget all about it in less than five minutes.

Find a good spot, turn the camera toward you, forget about the onlookers as much as you can, and just talk to your camera. When finished, instantly look down, look away and keep walking. If you don't make it a big deal, those around you won't either.

If you still simply cannot deal with people looking at you, step aside from the group so you are not in earshot. Find a wall, a corner, a tree or just a larger open space, and when you're finished join back in with the group.

Act casual

The less you pay attention to the people around you, the less you remember that they're even there and the less awkward and embarrassed you will be around them.

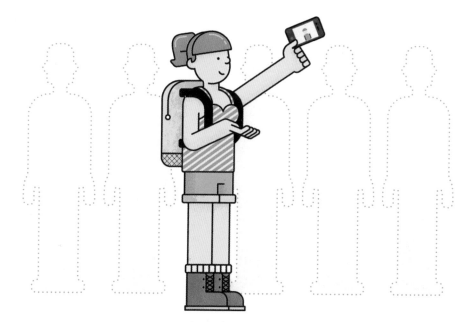

FINDING STORIES

The best stories don't usually present themselves to you in front of your camera. You have to go looking for them, and that requires some planning.

--

CREATIVE
TIPS

» Before you go, use your existing networks to find people in the country you're visiting. A quick post on social media might uncover friends of friends who live there. These people are an invaluable source of local knowledge, leading you to places and people you'd never find otherwise.

» See if there are any online newspapers from the country to learn about the current topics of debate, as well as upcoming events and interesting people.

» Pack an old unlocked phone and buy a cheap pay-as-you-go SIM card when you're

there. In many areas internet access is still scarce, but mobile phones are increasingly ubiquitous. Having a local number will make it easy to arrange filming people and events, and will help you keep in touch with useful contacts on the ground.

» Most importantly, talk to strangers. Talk to everyone you meet, find out about their life, their family and their dreams. If not them, perhaps they know others with interesting stories. Then be brave, and ask if you can film them.

THE CAMERA GETS YOU ACCESS

The wonderful thing about filming your travels is that, most of the time, people are very proud of their culture and jump at the chance to show it off.

The camera can act as an all-access pass, allowing you to attend events that you wouldn't usually be invited to.

Befriend organisers of events and tour leaders, and explain what you'd like to film, and why. Don't be afraid to use a bit of flattery: you might get the chance to film cultural or religious ceremonies that have never been seen before.

Once you're in there and filming, the camera gives you a valid excuse to ask questions, delve into people's lives and spend time with them without feeling awkward about why you're there. It can dissolve the boundaries between strangers.

Share the spoils

Get contact details from significant people you film so that you can send them a copy when you've edited it. Keep a note of whether they can access an internet link, or if you should send them a DVD instead. If you promise them a copy, make sure you send it.

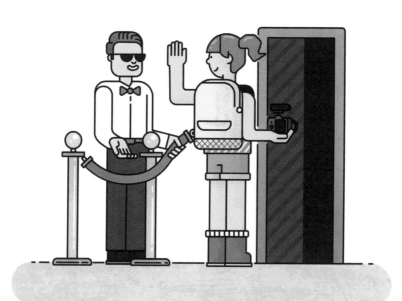

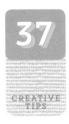

CREATIVE
TIPS

CULL THE CLICHÉ

Whether they mean to or not, everyone has a mental picture of their destination before they arrive. Don't just film what you expect to see.

The stereotypes presented by the tourist board will only represent a small fraction of what's really going on in a country. Very few Kenyans are Maasai warriors and Holland is not merely a collection of windmills and clogs.

It can be easy to fall into the trap of filming what you expected to before you arrived. Keep your mind open, read local papers, listen to what people are talking about and try to discover what matters to people. Search always for authenticity.

Forget the narrative that someone else has written about that place. Find different narratives that no one else has presented before. Try not to ask leading questions: sometimes, you may find people repeating the stereotypes back at you, because they think that's what you want to hear.

Look for ways to challenge accepted norms. Renowned photographer Martin Parr's iconic shot of the Leaning Tower of Pisa shows a host of tourists, all posing for the ubiquitous 'holding up the tower' snapshot in different positions. By stepping back and observing, Parr was able to shoot a world-famous attraction and present a social commentary simultaneously.

ESPAÑA

CREATIVE TIPS

LEARN THE ART OF PATIENCE

Be prepared to accept changes of plan graciously. Being flexible and open-minded will often open up more opportunities than you might think.

--

Capturing brilliant clips will always require patience. Events may be rescheduled; people may not turn up when you expect them to.

Don't hurry off as soon as you think you've got the shot: check if it could be improved. If you wait another ten minutes, the market stalls could burst into full flurry.

Observe your surroundings acutely and train yourself to wait to see what happens next or how the light changes: if you wait half an hour,

perhaps the rain will stop and the landscape will come to life again. The same rule applies to audio: that terrible drone of traffic might just peter off as rush hour passes.

It's the difference between quickly ticking off a shot and moving on without a backwards glance and allowing the scene to unfurl naturally and authentically around you. Sure, it can be frustrating, even boring, but with patience you'll always reap richer rewards.

CREATIVE
TIPS

TO SHOOT OR NOT TO SHOOT

Advances in digital technology have revolutionised video, but they have also made it all too easy to overshoot. Remember you'll have to edit it all.

In the era of film, there was a financial motivation to be selective with shots, as each roll of film cost money. Money is less of an issue these days, but storage space is a real concern when filming video, especially if shooting on 4K with a GoPro Hero 4, Sony A7 or similar. Large high-speed memory cards aren't cheap, so we find ourselves full circle to the old adage of selecting your shots carefully.

Editing is a time-consuming process, particularly if you are still getting to grips with the software. It's a simple equation, but the more you shoot, the more you have to edit. Plan ahead and decide exactly what you want

to appear in your final video, and it will save a lot of time further down the line.

As a rule, you probably don't want to be shooting much more than a 2:1 ratio, which means 50 per cent of your material ends up discarded. Those with more time on their hands for editing might push this up to 3:1, but much higher than this ratio and you'll be digitally drowning.

Don't forget the cutaways, as these are the visual links from one scene to another during the edit.

CHAPTER

EDITING
TIPS

TIPS BY Matt Sterling ✻ Russ Malkin ✻ Lucy Clements

EDITING SOFTWARE

Gone are the days of video-editing software costing big bucks. It is now easier than ever to edit videos to a high standard, and do so inexpensively and quickly.

From well-established programs like Final Cut Pro, iMovie or Windows Movie Maker, to smartphone apps designed for every conceivable occasion, there are innumerable tools out there to help you, and they're getting easier to use.

With such huge leaps in the quality of technology, the platform you choose generally doesn't matter a great deal, unless you want to turn your hobby into a full-time profession. So focus on finding a program you find easy to use. Many of the big video-editing programs,

like Avid Media Composer and Adobe Premiere, often offer 30-day free trials of their software, downloadable from their websites.

Above all, don't get hung up on what the technology can do for you. The best movies are ones that could have been cut on celluloid, by hand, as all films were for decades. When it comes down to it, it's not about the high-tech effects: good video relies on your ability to tell a great story and engage viewers. However smart it is, no computer algorithm can do that for you.

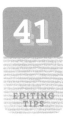

FIND YOUR TONE

What kind of video do you want to make? How should it make your viewer feel? When in doubt, the internet is a great place to start getting ideas.

Make use of the vast reference libraries of YouTube and Vimeo. Study the techniques in videos you like; make notes, if it helps. Vimeo in particular showcases an incredible selection of high-end travel videos and is a wonderful tool for novices. You won't be making perfect videos straight off the bat, so there's nothing wrong with learning from, and emulating, more experienced video creators until you find your own style.

When you've established your tone, keep it consistent. Don't try to be all things to all people: a movie with an inconsistent tone can be a mess, jumping from funny to serious to philosophical without warning and giving its viewers whiplash as they try to formulate their emotional response to it.

Choose your shots as they relate to your tone and story, and not how they relate solely to your sense of visual aesthetics. If the tone is slapstick, the stunning sunset you shot likely has no place in your video, no matter how remarkable it is. If a shot doesn't make sense in the context of the edit, be prepared to let it go. Don't worry about what you leave on the cutting-room floor: remember, the viewer will never see it and can't miss what they never had.

Music is an incredibly powerful tool for maintaining the tone of your videos, too: see page 106.

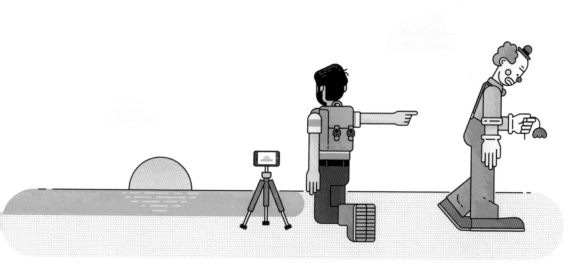

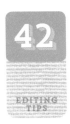

EDITING
TIPS

MIX UP YOUR SHOTS

When editing your own footage, it's important to shift your mindset from production to post-production. Time to mix things up a little.

There's a huge difference between being part of a moment in time (production) and watching that moment second-hand and after the fact (post-production); you can't assume viewers will experience it in the same way you did initially.

The way we process any visual information is dictated, intentionally or otherwise, by the compiler's choice of shot and sequence. When compiled well, they should direct the viewer's eye, telling them where their attention should be concentrated at any given moment: it's up to the content curator to decide how they want to tell the story.

If we see three shots of beautiful beach sunsets in a row, we as viewers learn that it was beautiful, then we learn the same thing twice more. But show us a beach sunset, followed by a couple walking hand-in-hand on the beach, then a close-up of their faces, and suddenly the sequence has new meaning: we're watching a love story.

Watching any movie or TV show on mute is a great way to learn how introducing visual variety (establishers, close-ups, cutaways, and so on) creates better narrative: each shot serves a function in the telling of a story and gives the audience another reason to stay engaged.

HONOUR THE PACE OF YOUR STORY

Pace is an innate component of any video: think of it as a steady heartbeat, pulsing rhythmically and carrying the audience along with it.

≫ Take a break between shooting and editing. Getting distance from the shooting experience is important: you might have attached more meaning to an event in the heat of the moment than is captured in the footage.

≫ Take the time to watch all the footage with as much of an objective eye as you can muster. Let it wash over you; get a bird's eye view of the raw material available before obsessing over specific moments.

≫ What do you remember most vividly from the raw footage? This is your hook: pitch the rhythm of your edit to match this. This is also an ideal time to think of any potential connections in your material.

The juxtaposition of any two shots can have implications for the viewer that range from the sublime to the absurd, but these reactions will never be prompted if you haven't taken the time to think through the possibilities.

≫ Be instinctive. See how it feels when you watch your edit back. Most of us have internalised the rhythms of video editing to an extent just by watching TV and movies. Trust your gut. If something feels off, it's probably with good reason. Never shy away from cutting the same scene multiple times. Like most creative endeavours, video editing is an iterative process and a skill that develops with experience.

KEEP IT SHORT AND SNAPPY

Don't fall into the trap of making your videos too long, and risk losing your viewer's concentration. Short and fun is always better than long and boring.

Avoid information overload. So-called 'talking heads' can be boring unless the subject is saying something fascinating or telling a good story. Keep these sequences no longer than 20 seconds, and where possible cut away to related clips.

Shoot cutaways. Have a strong selection of cutaway clips up your sleeve to break up long pieces to camera, or even to turn into a short sequence if needed.

Use music. It will help to hold the viewer's attention by setting a pace for the visual material you are presenting. The right soundtrack can add momentum or excitement, or emphasise the emotion, comedy or tension of a scene. For more tips on music usage, see page 106.

Follow the three-minute rule. Try not to exceed a video length of three minutes. If your content can't be condensed down to this length, consider splitting it into two or more shorter videos. If viewers are hungry for more, you can always direct them to the relevant webpage or link at the end of your videos.

EDITING TIPS

KNOW YOUR CUTS

It's not just content that counts. The transitions that replace one frame with the next in a video influence what the viewer understands about the narrative.

The most commonly used edit professionally is the **cut,** where one picture is simply replaced in the next frame by another picture.

Cross cutting cuts back and forth between two scenes to establish a relationship between them. It's good for building pace or tension.

Flash cutting uses very quick cuts where the shots last less than three seconds each. This adds chaotic energy (the German film *Run Lola Run* is a great example).

Jump cutting chops out intervening action while the position of the camera remains the same. Start with a long shot of a woman setting up her stall, for example, then cut to the same shot but with the stall now fully set up. It can add pace and a sense of fun.

Match cuts juxtapose two unrelated images to create meaning. A famous example is in *2001: a Space Odyssey;* a bone is thrown into the air before the shot cuts to a spaceship. Because the two are the roughly the same shape and size on screen, it creates a feeling of continuity. Placing them side by side imbues the cut with meaning: the development of humankind over millennia.

Other types of transition include **fading** in or out, which implies the beginning or end of a segment, and **cross dissolves,** which can be useful in things like landscape montages, helping to convey the passage of time.

CUTTING ON ACTION

Cutting on action, a hallmark of continuity editing, has been a central component of narrative film editing for more than a century.

Put simply, the principle is this: when cutting between camera angles, the action in those shots must match, to give a sense of continuous time.

Take a simple example of a girl walking her dog. If your first angle is a wide shot, with the dog walking to the girl's left, then the dog's position relative to the girl should remain consistent when you cut to another shot. The dog should not be suddenly lagging behind the girl or running ahead or on her right.

Ideally, when you cut between shots, your subjects should be moving at the same pace, with the motion of their bodies matching

closely (look for details like the positioning of limbs). In doing this, you create a visual bridge for the viewer, allowing their eyes to interpret the movement as one single action without distraction.

The movement must always be true to its own internal logic. If a frisbee leaves your frame to the right, it should re-enter in the next shot from the left (this is known as the 180° rule; see page 38). If your footage breaks this rule, there are work-arounds: most editing programs allow you to apply a 'flop' filter, to flip the image horizontally. Be careful: if there are words on clothing or signs, they too will be flipped!

USING MUSIC

Embrace the power of music. There's a reason so many narrative dramas score pivotal moments to well-known songs: the right music track can save the day.

If you've filmed sweeping pans of landscapes, pair them with epic orchestral music to enhance the sense of magnitude and grandeur in the scene. Action sequences call for a pacy beat, while a sad film may need soft, sparse music. Try different music cues as you edit your story. Cutting to the rhythm of the song is a great place to start. As you gain confidence, you'll find deeper ways to marry picture and music, and the results will be better for it.

The rights for commercial music can be very costly to use, even if your video is only intended to be shared on your own social networks. Investigate free stock music available on the internet – there are many options out there, including YouTube's music library, which has a great selection of 'free to use' tracks: **youtube.com/audiolibrary/music**. The iMovie app offers its own rights-free tracks at various lengths.

Compose your own soundtrack

If you are musically minded, or know someone who is, you can create your own music backgrounds – even by downloading simple music production apps like GarageBand on to your smartphone or computer.

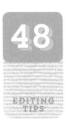

EDITING
TIPS

BE ORGANISED

It pays to keep your house in order when it comes to implementing a system for organising your archive. Keep things simple and robust.

Cameras and smartphones autoname the files you create. If you erase a memory card and reuse it, you may find the camera allocates the same filenames to your new footage. At best this is an inconvenience: you'll waste valuable time figuring out which footage belongs with which trip. At worst, video files of the wrong location can find their way into your edited movies and ruin your hard work.

Get into the habit of naming your files according to your own system. This may be by date, location, or theme. Keep it clear and consistent: it's easy to manage a motley set of files while you're shooting, but coming back in a couple of months you'll be at a loss to remember what logic you followed. And if someone helps you with edits, it needs to be logical to a third party too. So whatever system you choose must be simple and robust.

And as for the outtakes? Hard drives offer so much memory space at such good value that it's worth holding on to all the raw footage you shoot, even if doesn't make the cut for your current project. You never know what will have value to yourself or others in the future.

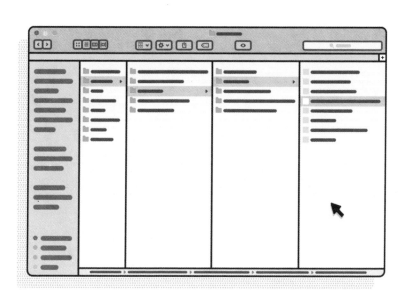

SHARING TIPS

TIPS BY Nadine Sykora ✳ Russ Malkin ✳ Emma Sparks

CHOOSE YOUR PLATFORM

All social media platforms allow users to embed video, and on Facebook you can upload movie files directly to your page. But there are two giants in the world of online video sharing: YouTube and Vimeo.

	PROS	CONS
YouTube	» **Enormously popular:** 1 billion active users every month, generating 4 billion views per day » **Revenue:** If your videos get enough views you'll be invited to a revenue sharing partnership » **Customisation:** You can style up your channel visually with backgrounds and themes » **Unlimited uploads**	» **Competition:** your videos risk getting lost in the sea of videos out there » **Comments:** YouTube's comments section is renowned for inappropriate remarks and spam » **Removal without warning:** YouTube can take down your video without warning if a community member flags it as inappropriate viewing
Vimeo	» **Quality:** Vimeo attracts the best-quality, most beautifully shot videos » **Layout:** a cleaner site and minimal ads (with a Pro account it's ad-free) » **Priority upload:** with a Pro account, you can upload cleaner videos quicker	» **Less traffic:** Vimeo is much smaller than YouTube – about a tenth of its size, in fact » **Cost:** the Pro account requires a fee to be paid. Some of the site's best features are only available via Pro » **Limited uploads:** maximum of 50GB per year

YOUTUBE: THE BASICS

Using a smartphone, you can film, edit and upload your finished video all on one device – incredibly quick and very practical. If your video was shot on a DSLR, it's just as straightforward to upload to YouTube from a laptop or desktop.

1 First things first; sign up for a YouTube account.

2 Next, click the upload button on the top right-hand corner.

3 Try to keep your file size under 800MB. Unless you are uploading 20+ minute-long videos, your file shouldn't be larger than this.

4 Give your video a title and choose a thumbnail. These are the two main selling points of your video, so choose them wisely! See page 116 for how to make the most of this.

5 Complete the description, making sure it lists what you are doing, where you are going, plus links to more information. If people are interested in finding out more, give them easy access.

6 Once you've uploaded your video to YouTube, copy the link to share to other social media platforms – or select the 'share' function on YouTube and it will do it for you, provided your other accounts are linked.

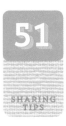

GET THE WORD OUT

Getting your video online is easy enough, but getting viewers beyond your own social circles to see it, share it and keep coming back for more is another matter.

» A strong title will pique people's interest. 'Bali, Indonesia' is fairly bland, but 'Secret places to discover in Bali' or 'Epic beach fun in Bali' are immediately more appetising.

» Pick the perfect thumbnail: ideally something unusual and eye-catching, offering a clear sense of location. And try to include people! Thumbnails with people typically get better views than landscape shots, since we connect more with faces and personalities.

» Tags are your metadata; they allow viewers to seek out what you're offering, rather than coming across it by chance (or not at all). Make sure you include all the places you have visited and any activities shown in the video.

» Playlists are a great way to keep people watching your videos. If you have similar videos from the same region, group them together in a playlist and share the link with your viewers to encourage them to engage with more of your content.

» Try sharing your content with companies who promote the activities that you are involved in. If it will help to promote them, they may offer to feature your videos on their sites.

» Encourage others to share your videos. Add a voiceover or blurb in the description asking viewers to share your video.

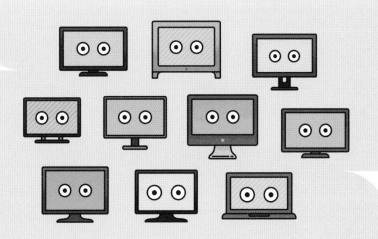

SHARING
TIPS

VINE VIDEOS

Vine is a social app that allows you to share six-second looping videos. It's a creative way to bring a destination to life for friends and family.

With a suite of simple yet effective tools, you can shoot, edit and save your snippets, all within the app. You are also able to upload existing clips, if you prefer. To record, just press and hold your finger on the screen when in filming mode.

While it is possible to create impressive time lapse effects, slick edits and stop motions, the beauty of Vine is in its simplicity. Here are some basic tips for novice travel vine creators:

》 Stick to the basic 'one shot, six-second postcard' technique, by holding the camera completely still or panning *slowly* to capture the scene.

》 Hold your phone steady. This is the golden rule. Shaky hands? Use a tripod or double tap the grid icon in the Vine filming tool box for a handy level guide.

》 Think like a photographer. Is the light on your subject? Is there anything unnecessary in the shot? Think about composition before you start recording.

Follow **@lonelyplanet** for inspiration and tag us in your travel vines – we share the best with our fans!

Vine developers are constantly improving the app. Visit **blog.vine.co/** for news and tips.

GLOSSARY

aperture
the opening in the lens that allows light into the camera body; variable in size and expressed in f-numbers or f-stops

aspect ratio
the ratio of the width to the height of a frame, commonly expressed as two numbers with a colon between them, eg 16:9

composition
the arrangement of visual elements in any one frame

cutaway
a shot or scene in a film which is of a different subject from those to which it is joined in editing

cutting on action
an editing technique where the editor cuts from one shot of a subject to another view that matches the first shot's action

depth of field
the area of a frame, in front of and behind the point of focus, that is considered acceptably sharp

DSLR camera
digital single-lens reflex camera

exposure
the amount of light allowed to reach the camera sensor or film

GoPro
an HD-quality, waterproof video recording device that can be worn or mounted on vehicles, popular for capturing action and adventure sports footage

image stabilisation
techniques used to reduce the blurring associated with the motion of the camera during exposure

ISO
International Organization for Standardization, which sets the standards for film-speed rating

lens hood
a tube or ring attached to the front of a camera lens to prevent unwanted light from reaching the film

panning
a camera movement technique whereby the camera moves horizontally to the left or right

resolution
the degree to which digitally captured information displays detail, sharpness and colour accuracy

time-lapse
a technique whereby the frequency at which film frames are captured is much lower than that used to view the sequence, making footage appear sped up

tracking
a camera movement technique whereby the camera follows a subject by moving alongside it

vlog
a video blog

white balance
digital camera function that adjusts colour to ensure that white is recorded as white under all light conditions

wild track
an audio recording intended to be synchronised with film or video but recorded separately from picture

INDEX

INDEX

ABOUT THE AUTHORS

Lucy Clements has a long-held passion for making films and travelling. After eight years of filming around the world with the advertising industry, shooting award-winning short films on the side, she moved to Uganda with a camera to see what stories she could find. Sometimes they turn out to be what she expects, but she's always searching above all for the people who shatter the stereotypes and challenge assumptions.

Russ Malkin is a British TV and film producer, creative director, writer and all-round entrepreneur with a relentless passion for adventure. As well as travelling the world, Russ loves fast-moving machines and has delivered some of the world's most exhilarating global sports and event television, including the motorcycle adventure TV documentaries *Long Way Round* and *Long Way Down* featuring Charley Boorman and Ewan McGregor. In 2011 Russ wrote *Big Earth's 101 Amazing Adventures*, drawing on his filming experiences as well as some of his other favourite personal adventures.

Nick Ray has worked in film and television in Southeast Asia for 15 years. He first came to Cambodia on assignment with Lonely Planet back in 1998 and has since worked as a location scout, location manager, line producer and camera operator on a wide range of shoots in the region. His credits include Location Manager on *Tomb Raider*, Line Producer on the *Top Gear* Vietnam special, and Executive Producer on the award-winning Cambodian film *The Last Reel*.

Emma Sparks spent over a year in the much-coveted role of Lonely Planet's social media coordinator. She has since moved on to become deputy editor of lonelyplanet.com – but continues to Vine and tweet about her travels @Emma_Sparks.

Matthew Sterling is a film and video editor whose career encompasses everything from music videos and web series to broadcast television and theatrical films. Working for Sundance Channel, AMC, and others, he produced and edited several Promax Award-winning campaigns and received multiple "Best Editing" honors, as well as editing two theatrical feature films. He now works at NC2 Media.

Not quite ready to settle down after university, **Nadine Sykora** set off on a working holiday to New Zealand armed with a trusty video camera. There she decided to vlog her travels, mishaps and adventures, and share them with the internet and on social media. She loved it so much she decided to keep travelling, and keep vlogging. She now travels full time, creating entertaining travel videos full of wanderlust, comedy and inspiration to continue sharing to the world.

Teton Gravity Research is an action sports media company based in Jackson Hole, Wyoming. Founded in 1996 by brothers Steve and Todd Jones, TGR has produced dozens of award-winning action sports films rooted in skiing, snowboarding and surfing, as well as numerous original television broadcast series. Contributors from TGR:

Blake Campbell is TGR's Lead Editor, managing the wealth of footage TGR shoots every year. He has travelled with the crew as a producer, director, sound technician and camera operator.

Jonathan Desabris is an avid whitewater kayaker, backcountry skier, and lover of all things outdoors. He's obsessed with trying to capture and record the moment.

Greg Epstein oversees video production at TGR. He manages shooting logistics on several high-intensity video productions simultaneously, constantly 'chasing snow' around the globe.

Austin Hopkins is an action sport enthusiast and producer who shares his passion with the community, creating short films and feature-length projects with TGR.

Nick Kalisz loves using video to capture the medium of motion and how things move through space and time. His best advice? Get outside and experience that next great thing you dream about.

ACKNOWLEDGEMENTS

PUBLISHING DIRECTOR Piers Pickard
COMMISSIONING EDITOR Jessica Cole
LAYOUT DESIGNER Austin Taylor
ILLUSTRATOR Crush
COVER DESIGNER Wendy Wright
PRINT PRODUCTION Larissa Frost,
Nigel Longuet
WRITTEN BY Lucy Clements, Russ Malkin,
Nick Ray, Matthew Sterling, Emma Sparks, Nadine
Sykora, and contributors from Teton Gravity
Research (Blake Campbell, Jonathan Desabris,
Greg Epstein, Austin Hopkins, Nick Kalisz)

Published in August 2015 by
Lonely Planet Publications Pty Ltd
ABN 36 005 607 983
www.lonelyplanet.com
ISBN 978 1 7436 0758 9
© Lonely Planet 2015
Printed in China

LONELY PLANET OFFICES

Australia
90 Maribyrnong St, Footscray, Victoria, 3011, Australia
Phone 03 8379 8000 Email talk2us@lonelyplanet.com.au

USA
150 Linden St, Oakland, CA 94607
Phone 510 250 6400 Email info@lonelyplanet.com

United Kingdom
240 Blackfriars Road, London SE1 8NW
Phone 020 3771 5100 Email go@lonelyplanet.co.uk

Paper in this book is certified
against the Forest Stewardship
Council™ standards. FSC™ promotes
environmentally responsible, socially
beneficial and economically viable
management of the world's forests.